A·HENDERSON '93.

ks Ari
34/23
BD

CITIES

Stephen Wiltshire

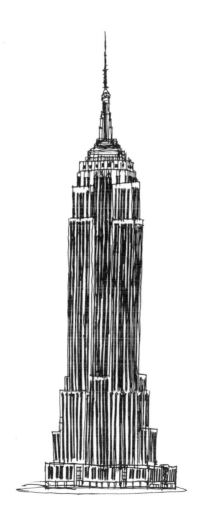

J. M. Dent & Sons Ltd · London

First published in Great Britain in 1989
Illustrations copyright © Stephen Wiltshire 1989
Text copyright © J. M. Dent & Sons Ltd 1989

Printed and bound in Great Britain by
Butler & Tanner Ltd, Frome and London
for

J. M. Dent & Sons Ltd
91 Clapham High St
London SW4 7TA

British Library Cataloguing in Publication Data

Wiltshire, Stephen, 1974–
 Cities.
 1. English autistics children's drawings. Wiltshire,
 Stephen. Special subjects: Buildings – Illustrations
 I. Title
 741.942

ISBN 0–460–04780–9

Acknowledgements

Since the publication of *Drawings* in 1987 many people and organisations have lent their support and encouragement to Stephen's talent. The list is too long to mention everyone by name, but particular thanks are due to The Building Centre (London), Independent Television News, London City Airways, London Docklands Development Corporation, Reeves Art Materials, the Royal Incorporation of Architects in Scotland (Edinburgh) and, outstandingly, to Mrs Lorraine Cole and Mr Chris Marris.

FOREWORD
by Oliver Sacks

Another volume of Stephen Wiltshire drawings? Wasn't one enough? One would have been enough if Stephen were merely a prodigy – or a clinical phenomenon. But he is more: he is a sort of genius. And genius develops – brings new things from its depths.

Since the age of four Stephen, though otherwise withdrawn and mute, had been fascinated by pictures. This was his one interest, his one connection with the world. Soon after this he started to draw, to derive huge pleasure from drawing. When he was seven or so, he did a series of 'wickedly clever caricatures of members of staff, laughing very loudly at the effect they produced' (so his former headmistress informs us). But he was attracted, always, to the drawing of *buildings* – and cities. Whether they appealed to his formal sense of space and symmetry, so astonishingly and powerfully developed, or to something secret and symbolic in him – perhaps the sense of habitation or home he has been tragically deprived of – is not clear. His love of buildings is central and constant – and when he 'grows up', he says, he wants to be an architect.

The first volume of Stephen's drawings showed this passion, and his remarkable power to perceive, to remember, to draw. They had a perceptual fidelity, a mechanical fidelity, which was stunning; but, over and above this, they hinted at a delightful, very human personality and style. One had to wonder what would happen to him: would he simply continue, repertorially, in the same way? Would he – like Nadia, a prodigious autist artist, who drew Picasso-like footballers and bullfighters when she was three – learn to talk, to 'interact' and would this lead to the vanishing of his strange gift? Or – the most exciting possibility of all – might he go on to a real, creative expansion and development? This new collection of Stephen's drawings shows that it is the last that is happening.

There has always been a popular fascination with idiot-savants, as they were called (there is a tendency, now, to drop the 'idiot', and to speak, no less baffledly, of 'savant syndrome') and there is no doubt that Stephen is both autistic and a 'savant' (he is very far from being an idiot – he has a

very clear, very individual and very playful, mind). The combination of great abilities with great *dis*abilities presents an extraordinary, (and, in human terms, poignant) paradox and problem – how can such opposites live side by side? There is a strong tendency to see these as organically related – to see the gifts of the autistic (and about 10% of them are so gifted) as stemming directly from their failures and deficits – their narrow, 'hyper-focussed' attention, and their supposed inability to process visual information, to pass from percepts to concepts, so that, in the visual realm, for example, it has been said that they merely 'see' what is there. Sir Hugh Casson, introducing the first volume of Stephen's drawings, says that 'Unlike most children, who tend to draw less from direct observation than from symbols or images seen second-hand, Stephen draws exactly what he sees – no more, no less.' But what *does* he 'see'? What is 'seeing' – for Stephen; or, for that matter, for the rest of us? Is Stephen no more than a sort of wonderful human camera? The great Cambridge psychologist Frederic Bartlett made a lifetime's study of remembering – he would never speak of 'memory', always of 'remembering' – and always depicted it as personal and active, never as mechanical or passive. It is not reproduction, but reconstruction, he would say – in remembering, as in perceiving, there is an agent, a *person* at work, selecting, editing, emphasizing, like a dreamer or creator (though Bartlett never read Freud, he often sounds like him). And yet, clearly, it is not *just* reconstructing and editing; there is a primary perceptual capacity, and reproductive capacity, which provides the material itself. And in the autistic savant, this reproductive capacity is overwhelmingly strong – probably on a physiological or constitutional basis. (It was overwhelmingly strong in Mozart as well, who, even as a child, could reproduce any piece after a single hearing.)

An overwhelming capacity – an overwhelming memory-capacity for example – can be a curse or a blessing. Sherashevsky, Luria's famous Mnemonist, was *engulfed* by his enormous, involuntary powers of imagery and memory, taken over by them, so that he hardly lived in the real world any more. An 'It', as Luria puts it, was too powerful here for its possessor – 'It' took over, and dispossessed the man. Something similar seems to happen with many 'savants' – especially if they are severely limited intellectually or emotionally, or if the demands of public performance (as was the case with Luria's *Mnemonist*, and the savant twins I have described elsewhere) force them into a sterile, repertorial routine. The savant all too readily becomes a virtuoso – it is much rarer for him to develop into a genuine artist. Stephen, however, seems to be one of the happy exceptions. In him, as in other, non-savant artists, the strength of the individual, his ego-strength, his creativity,

his humour, his 'Stephenness', instead of being overwhelmed by, or passively colluding with, a great constitutional power, seems able to use, to harness, this power creatively.

I had heard something of Stephen, and seen some of his drawings before they were published, and was very curious to see him, and to see him drawing, for myself. This was possible (in February 1988) when he came to New York (along with his teacher and an I T N television film team). I greeted him, I observed him, on three levels: first, on the human level – because he was a charming, rather demure, grave-seeming boy with an unexpected and sometimes outrageous sense of humour, obviously enjoying his trip to New York thoroughly; second, on the clinical level because there was something odd about him, a deficiency of eye-contact and social interaction – he was still, very evidently, withdrawn and autistic; third, with eyes of wonder, as I watched him draw . . . but this was not till later. He showed me his drawings, his Manhattan portfolio – delighting especially, I thought, in the aerial perspectives he had caught when flying over it in a 'copter. He seemed sure of himself, of his unusual powers, but entirely unspoilt and modest. After he had shown me his Manhattan drawings, I asked him if he would draw something for me – my house, perhaps? Stephen nodded, and we wandered outside. It was snowing, cold and wet, not a day to linger. Stephen bestowed a brief, indifferent glance at my house – there hardly seemed to be any act of attention – glanced then at the rest of the road, the sea, then asked to come in. As he took up his pen and started drawing, I held my breath. It made me think of the child Mozart at the piano. 'You needn't hold your breath', the cameraman broke in, 'You can talk at the top of your voice if you want to. It won't make any difference – you *can't* interrupt him – he could concentrate if the house was falling down.' Stephen started at one edge of the paper (I had a feeling he might have started anywhere at all), and steadily moved across it – as if transcribing some tenacious inner image or visualization. It was not quite like 'ordinary' drawing, but as if he had a camera lucida in his head which every so often he would pause over and consult. As he was putting in the railings, the cameraman called out again, 'Coo, Stephen, I didn't see any of that there detail there.' 'No' said Stephen quietly, 'no, you wouldn't.' When he finished he drew a line under the house, which he extended a yard to the right. I thought for a moment, we all thought – perhaps too this was Stephen's thought – that he would go on to draw the entire street (I had no doubt that he had 'snapped' this in his brief, apparently perfunctory, but all-seeing glance); but, somewhat to my regret, the paper was then taken from him. Stephen drew my house very quickly – it was a mere sketch, not one of his 'productions', but the general shape, the

feel of the little house is beautifully got. It is very accurate, in some ways, but takes all sorts of liberties in other ways – quite unlike a photograph. Stephen has given my house a chimney (I have no chimney), but has omitted the three fir trees in front of the house. He has also omitted the picket fence round the house, and the neighbouring houses to either side. He has focussed *on* the house, to the exclusion of anything else. It cannot be said that 'He draws what he sees' neither more nor less.

Such editing, such construction, occurs in all of his drawings – there is never any fussy, *unnecessary* detail. Stephen *sees* all the details (and sometimes invents details) – but only puts in what serves the process of Art; his prodigious powers of perception and memory do not overwhelm him, but provide, rather, the springboard from which his creativity leaps. None of his drawings is ever boring – Stephen *selects* what he will put in or leave out, *selects* the point of view (often an aerial, imaginary one – he loves to look down on, or

Olivers sabKs house

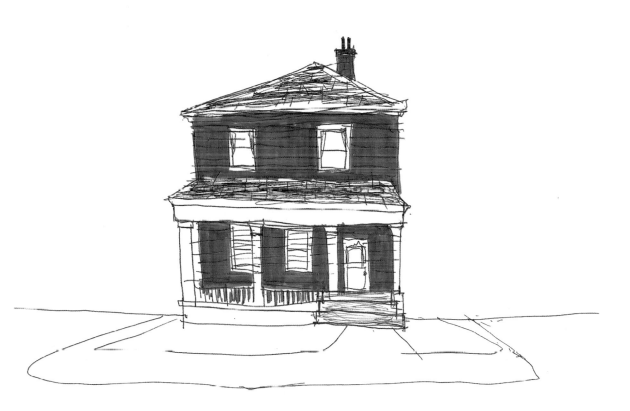

7

imagine, vast city panoramas), *selects* the mood and style and 'tone' of each drawing. His powers of memory, of imagery, of perception are immense, but they are at the service of a sophisticated artistic judgement and taste – and the advances in taste, in artistic judgement, as in technique, have been very dramatic in the last two years. There was something wonderful, but childlike, in many of his previous drawings – but the finest ones here in this new collection show unequivocal and mature mastery.

The finest, and most astonishing, to my mind, are his drawings of imaginary cities, which conflate elements of London and New York, and plans of as-yet-unbuilt structures (planned for London's Dockland), with completely invented and imaginary structures. These magnificently-realized, visionary drawings have a vastness, a grandeur, which is entirely new in Stephen's work, and show him moving from a modest to a major creativity.

But equally, at a more human level, there are changes and advances. *People* are portrayed more frequently – and sympathetically (they were often no more than stick-figures before). There is a lovely Chagall- or Picasso-like quality to his skaters in Rockefeller Center (and he has humorously given the draped Prometheus overlooking them a *membrum viril* – Stephen is becoming an adolescent now). Here, as in all his drawings, playfulness is pre-eminent – and playfulness is the first and last sign of a creator.

I think we may be more confident and optimistic about Stephen's future than was the case two years ago. Far from standing still, or resting on his laurels, or stagnating in a fixed repertoire, he has moved to new levels of conception and achievement – his imagination and his technique have increased apace. Whilst he remains autistic (and may always remain so) his ego-strength, his humour, his love of the world (it is certain, at least, that he loves buildings and cities), and, above all, the strength and originality of his creative imagination (and it is *this* which is the deepest, most mysterious quality of all) will, it seems increasingly likely, enable him to transcend his autism (while making use of its strengths), and become a unique recorder and imaginer of our times.

INTRODUCTION
by Anthony Clare

One of the most persistent, intractible and irritating assumptions concerning mental impairment and handicap is that individuals so afflicted are in some way less than human. At its least offensive, it shows up in a paternalistic concern and a preoccupation with protection. At its worst, it leads to indifference and hostility. No matter that those closest to mentally impaired individuals continually insist that for the most part even the most seriously affected have qualities and talents worthy of nurture and respect. The prevailing tendency is to regard such individuals as inherently distinct, different, inferior.

In 1987, an opportunity to challenge such assumptions presented itself when the BBC produced a QED television programme entitled *The Foolish Wise Ones* which I was fortunate enough to narrate. Now, the title, as English translation of the French term 'idiot savant', served to emphasise the remarkable paradox whereby some individuals with a variety of general mental handicaps including an inability to learn, read, speak and relate to others, can manifest highly developed specific mental skills. Clinically, I knew of such individuals. I also knew, however, that very often the abilities concerned are of somewhat repetitive, mechanical and unimaginative nature, such as an uncanny photographic memory which recalls virtually everything but is unable to discriminate between material worth recalling and material of no use to anyone; or a bewildering and meticulous mastery of complex railway or bus time-tables, useful to anyone who might want a comprehensive account of how often and how best one might get from Putney to Hampstead Heath but of limited value otherwise. However, one of the children in the QED programme, a young boy with a history of severe speech impairment and behavioural difficulties from early childhood, possessed an ability of a quite different order.

Stephen Wiltshire's talent was and is to draw. But that is to put it mildly. Such is the natural and exceptional nature of his talent that Sir Hugh Casson was moved to declare him to be possibly the best child artist in Britain. The programme led to the publication of some of Stephen's drawings of well-

known London landmarks and these were greeted with widespread astonishment and acclaim.

Now, I am aware that it is somewhat fashionable to criticise the media in their handling of medical matters and to accuse journalists of being more interested in entertaining than informing. Yet *The Foolish Wise Ones* illustrates how television can do both and do them well. Viewers could see Stephen for themselves. They could hear his personal story – his language impairment, his social withdrawal, his isolation at school, his rapt absorption in drawing. And, television's crucial ability, the programme showed Stephen's creations – remarkable freehand, detailed, three-dimensional sketches of some of London's most famous landmarks undertaken with zest, confidence, entirely from memory and without notes. His series of quite remarkable pictures did more than challenge popular assumptions and misconceptions concerning mentally impaired children. It put back into the very centre of the stage uncomfortable questions such as how many other talented people are hidden behind barriers of speech difficulties, learning impairment, social withdrawal and how might we find and nurture them?

Since the programme Stephen has had the thrill of seeing his work widely appreciated and his drawings become sought after by would-be purchasers. He has flown to the United States on a jumbo jet, seen and drawn the Empire State Building, met and marvelled at Michael Crawford in *The Phantom of the Opera* on Broadway. He has travelled to Paris and applied his draughtsman's skills to drawing such majestic architectural achievements as Notre Dame and the Pompidou Centre. His confidence has prospered and he has learned to read and write. In short, the story of Stephen Wiltshire is the story of a talent locked behind a wall of mental impairment which, on being released, has not merely flourished but has enabled the impairments to be tackled and a whole life transformed.

And there is the lesson. As we must seek, find and cultivate talent in children who are mentally unimpaired and psychologically intact, so too must we endeavour to encourage those children who for a variety of reasons suffer learning difficulties and mental impairment. Handicap is not a signal to us to cease to undertake the search. It is the stimulus to us to engage in it with particular vigour. Not every healthy child has the genius of a professional artist. Not every impaired child has the precocious skills of Stephen Wiltshire. But we would be wise to operate on the assumption that everyone has some skill, aptitude, ability which properly nourished can provide satisfaction and delight to all of us.

COMMENT
by Chris Marris

Chris Marris was Stephen's teacher at the Ilea School he attended from January 1979 to July 1987. They have become firm friends and Chris continues to see Stephen regularly and to encourage him with his drawing.

It was Stephen's first flight and I was wondering how he would react to a seven hour journey to New York. He listened to the rock music on the headset and as the runway fell away he looked out of the window and said one word: 'Wow!'. I knew then that he was going to enjoy the trip.

He proved to be a charming travelling companion. He talked with the cabin crew and other passengers, showing his book of Drawings around as we flew. He was invited to sit in the 'jump seat' for the landing in New York and realised a dream – 'I am being the pilot of the jumbo jet and I can see the skyscrapers and the Manhattan skyline'.

We went to the top of the Empire State Building at night, something which was on his list of things to do in New York. He visited the twin towers of the World Trade Centre and saw New York from the observation deck on a very cold, clear, sunny morning. We flew in a helicopter around the Chrysler building, the Statue of Liberty and over Brooklyn Bridge at three hundred feet. Stephen was thrilled to see it all.

He met Michael Crawford on Broadway to see the set for the *Phantom of the Opera* and while waiting for Mr Crawford to put on his Phantom Mask (specially for Stephen), he mimed to a Beatles record on the stage of the Majestic Theatre. Towards the end of our trip we visited Dr Oliver Sacks and Stephen talked confidently about the drawings he had done in New York. After a few minutes standing outside in the falling snow, he drew a quick sketch of Dr Sack's house.

On our return to London I asked him where he would like to go next. 'Paris' he said, 'Oh, and Manchester'. We haven't made it to Manchester yet but in October 1988 Stephen travelled to Paris. Unlike the New York drawings, which were all done from memory perhaps an hour or two after visiting the buildings, he drew the Paris buildings from life. First on his list

was the Eiffel Tower. 'It's nice' he said. Then to Notre Dame, where like a true pavement artist he sprawled on the steps of the square, surrounded by holidaying British school children, who had seen him on the telly, and interested Parisians. 'Bonjour!' Stephen would say as he looked up periodically from his drawing.

The Pompidou Centre proved no problem for him as he sat in the early morning with his drawing board resting on a café table. Then we went by Metro to Sacré-Cœur where, sitting on the steps to draw, Stephen again attracted a small crowd of children and two Gendarmes, all enthralled at the rapid and confident lines flowing from his pen.

Another building, complex and seemingly difficult for any artist to attempt, was drawn standing in the doorway of a bank – the Opéra. I asked him what he thought of it.

'It's nice I think. Good.'

'And is your drawing good Stephen?'

'Yes, it's good I think. Excellent.'

Many other drawings in this volume are also done from life. Stephen has been drawing the buildings of London since well before I met him at the school in West London in 1982. These after-school and Saturday morning outings since April 1988 have proved to be very successful and there always seems to be something else to draw. Stephen will seemingly never run out of subjects!

As he drew the Albert Memorial one Saturday morning (beginning with the elephant in the lower left hand corner of the page) I was struck again by the magical quality of his work. There seems almost to be an unknown force at work – a sixth sense which somehow defies measurement or assessment.

Stephen is at secondary school now and has coped with the changes well. I am continuing to meet him regularly outside school hours. So far his language is developing and becoming more complex, sophisticated and mature – as in some ways are his drawings. There is more variety, particularly in his use of colour. Using drawing board and straightedge, Stephen has produced technically excellent work and his Docklands material (produced from photographs of existing buildings and photographs of models of buildings yet to be constructed) is often combined into almost imaginary city scapes. There are his memory drawings and his life drawings; he is experimenting with designs, making wonderfully intricate models from paper and card. Perhaps now his originality will develop and he will really begin to create his own designs and become an architect, as he says.

I am sure we can look forward to a continuing flow of wonderful drawings. Stephen has a long list of cities to visit in the future!

PARIS

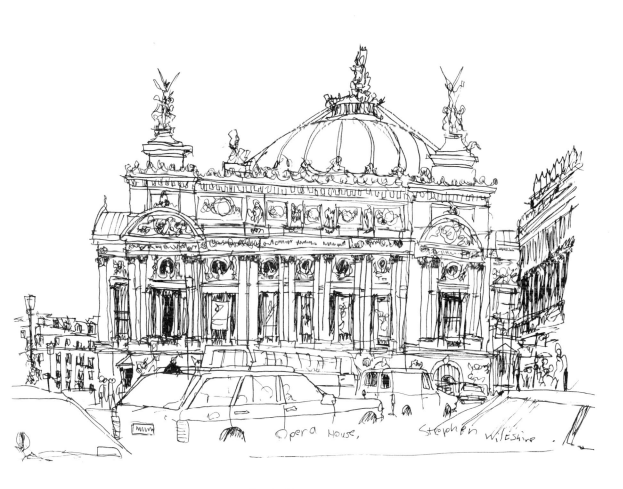

Paris Opera House

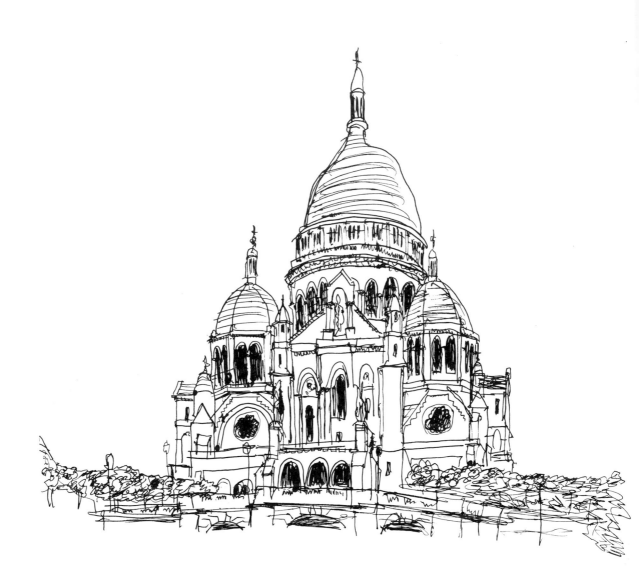

Sacré-Cœur

14

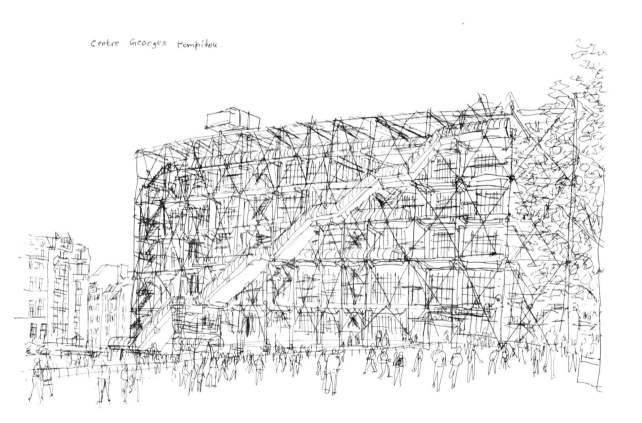

Pompidou Centre

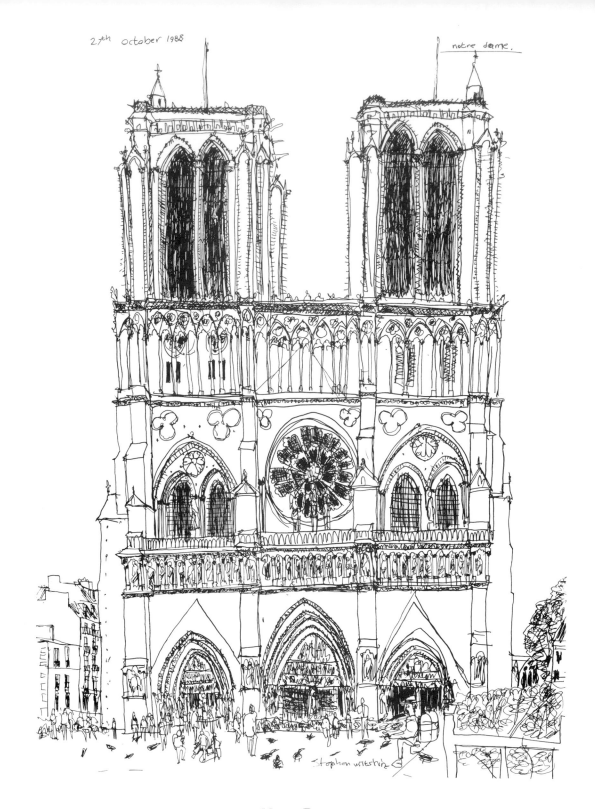

27th october 1988

notre dame.

Stephen Wiltshire

Notre Dame

16

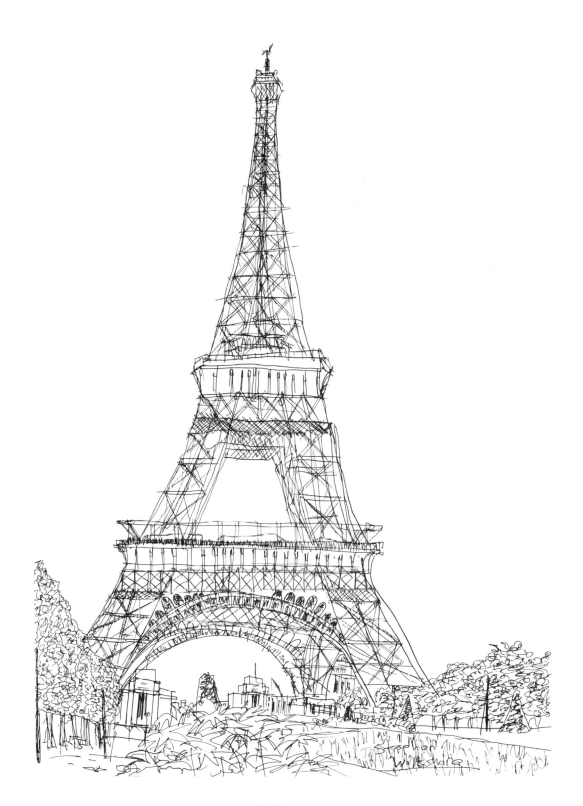

Eiffel Tower

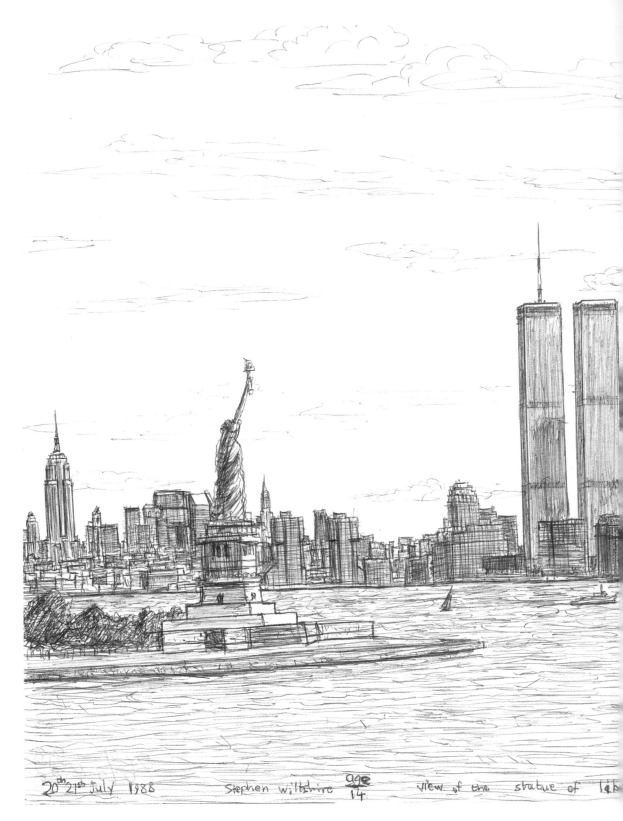

20th 21st July 1988 Stephen Wiltshire age 14 view of the statue of lib

View of Statue of Liberty and Manhattan Skyline

NEW YORK

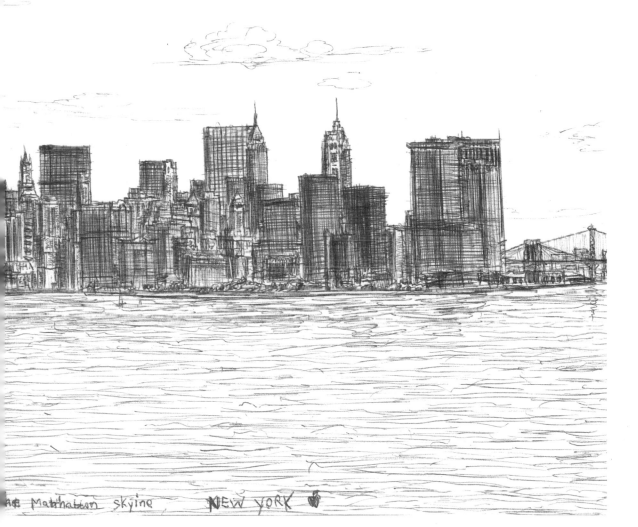

the Manhattan skyline NEW YORK

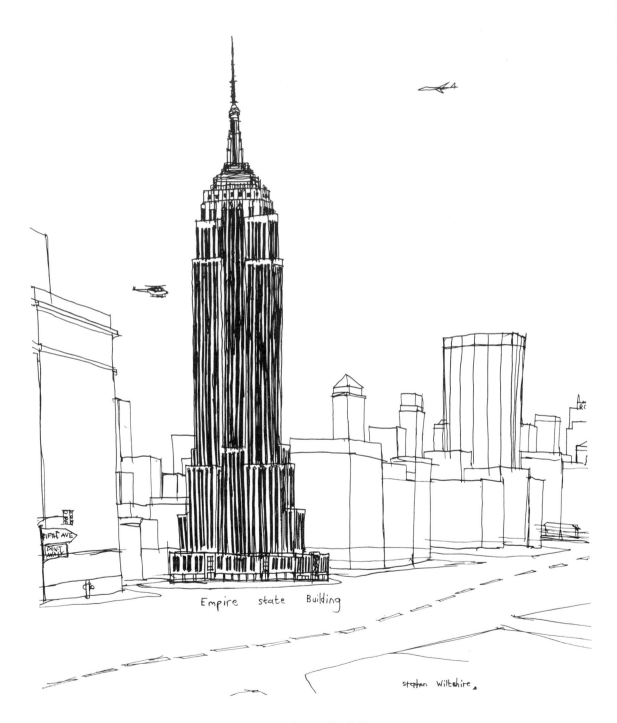

Empire State Building

NEW
YORK

chrysler Building.

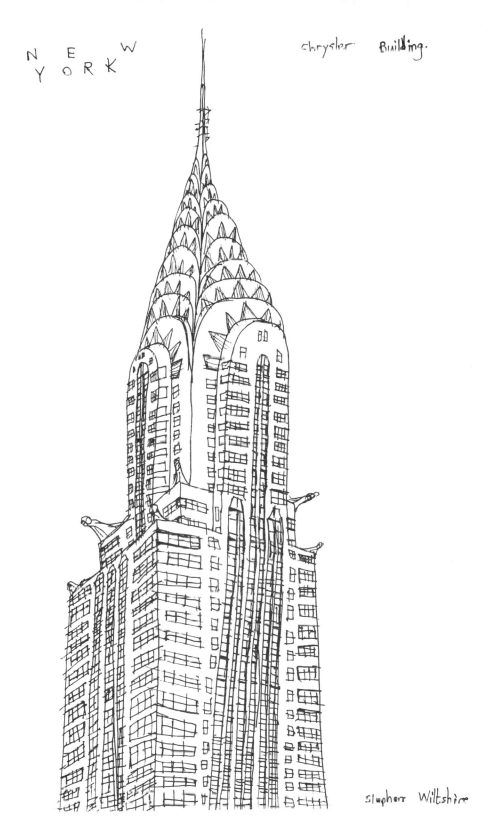

Stephen Wiltshire

Chrysler Building

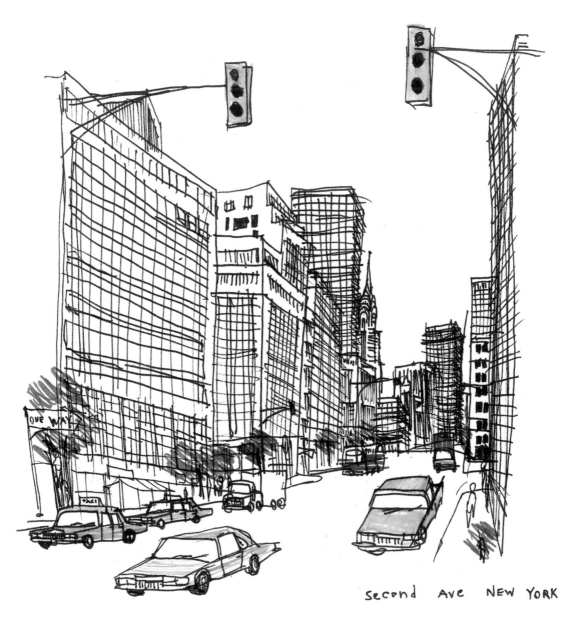

Stephen Wiltshire

second Ave NEW YORK

Second Avenue

Ronald McDonald

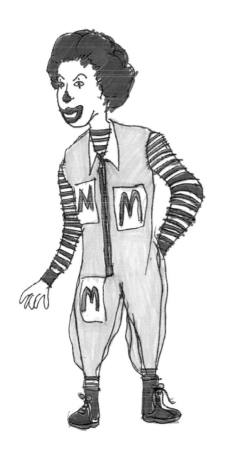

Fire Engine

Police ear

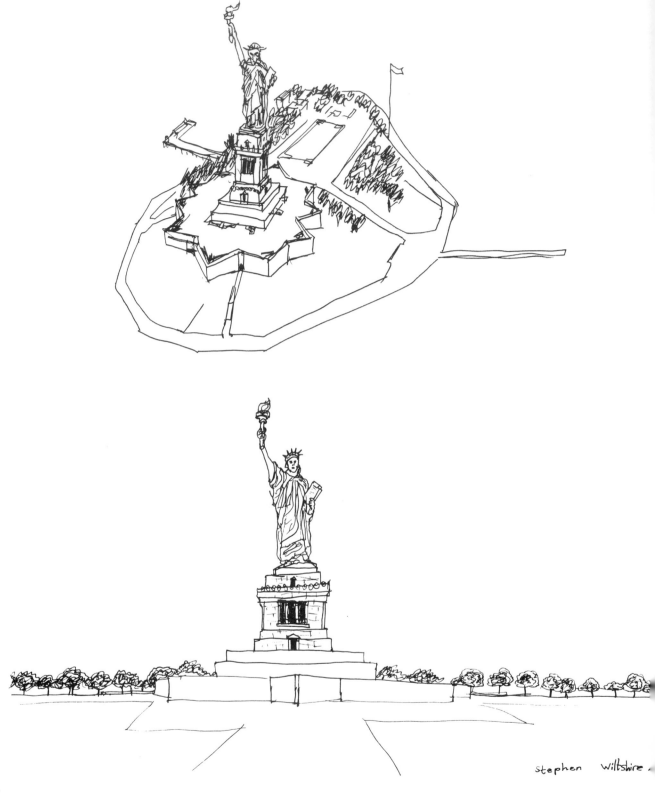

stephen wiltshire

Statue of Liberty

NEW 🍎 YORK.

UNITED STATES POST OFFICE

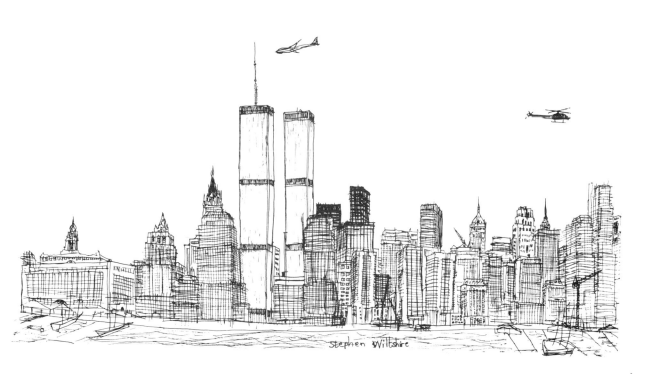

Stephen Wiltshire

View of the World Trade Centre

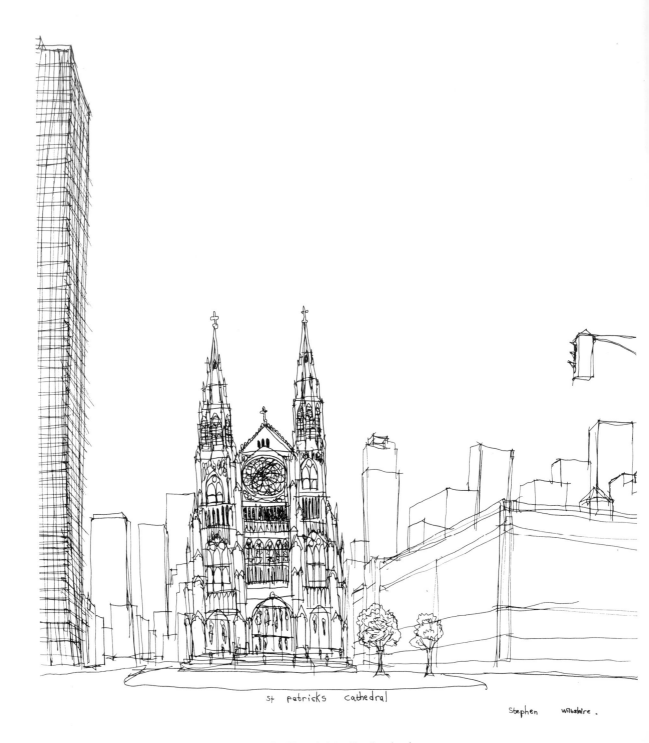

St Patrick's Cathedral

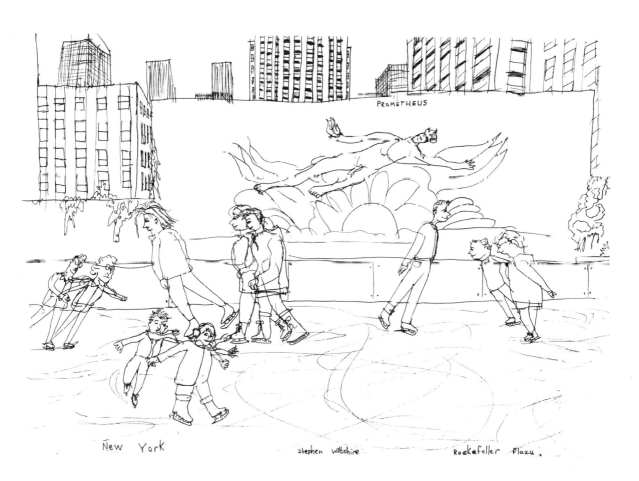

Rockefeller Plaza

Michael Crawford

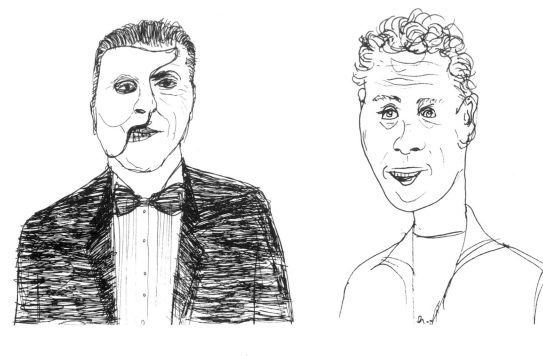

by stephen wiltshire.

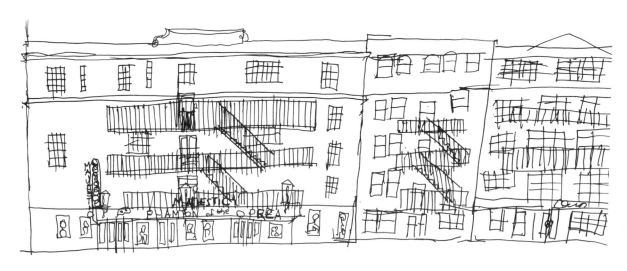

Majestic Theatre

LONDON

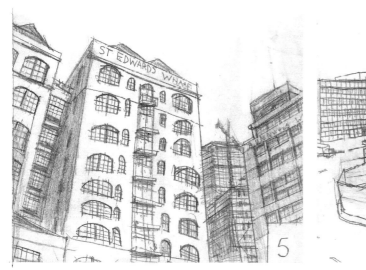

St Edward's Wharf

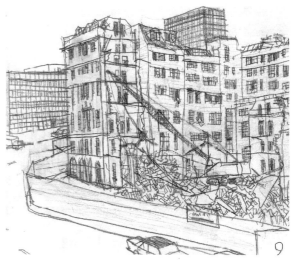

Demolition

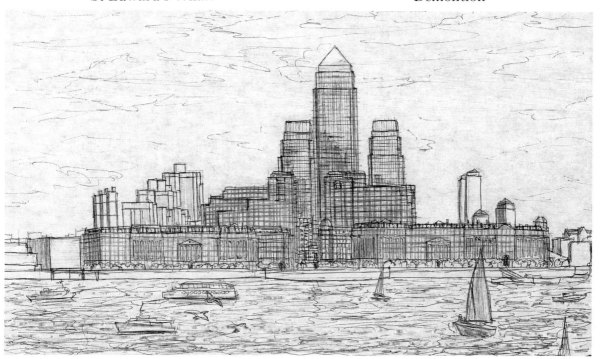

Canary Wharf

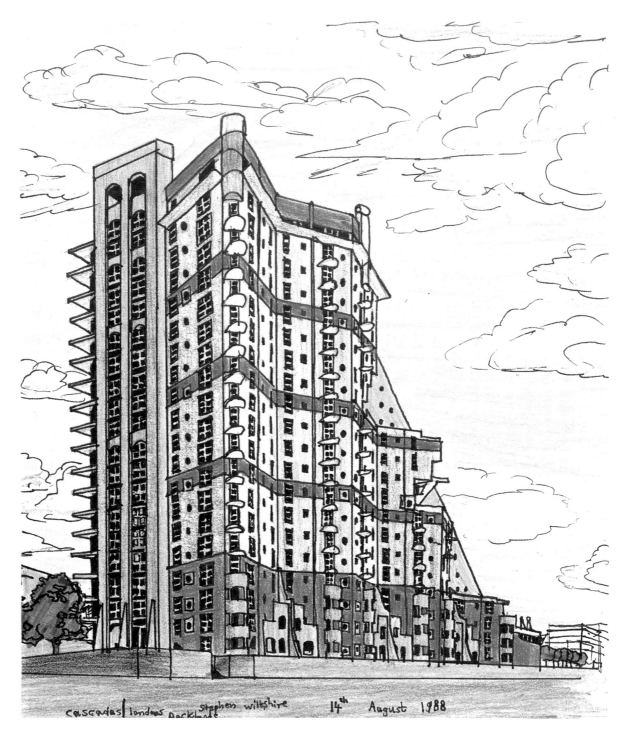

Cascades, London's Docklands

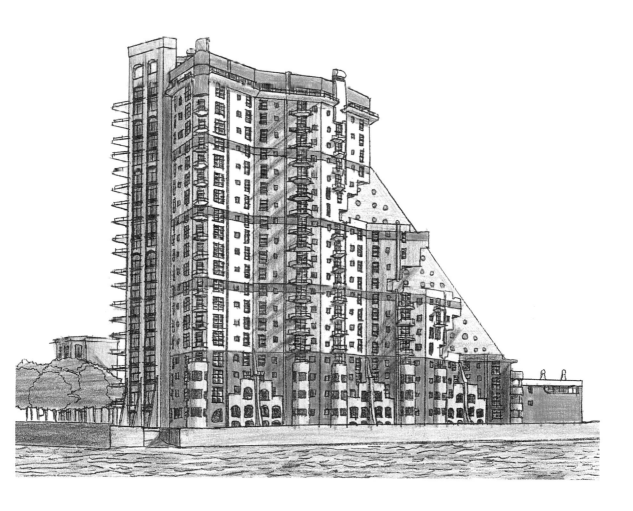

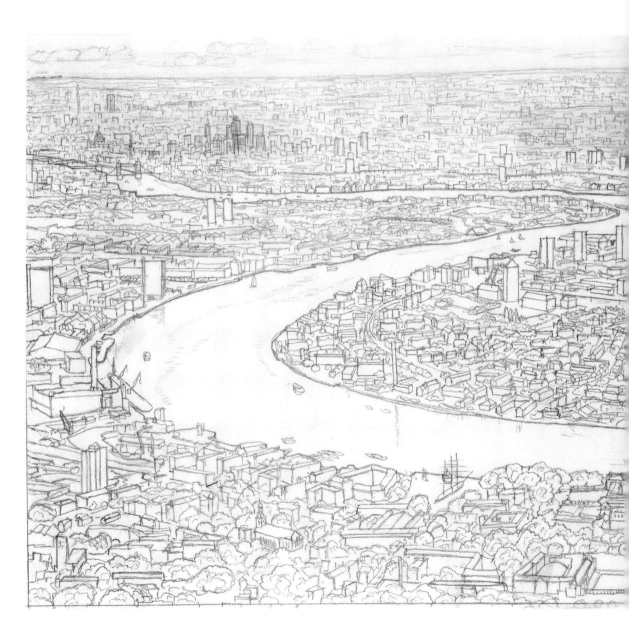

Aerial view of Docklands

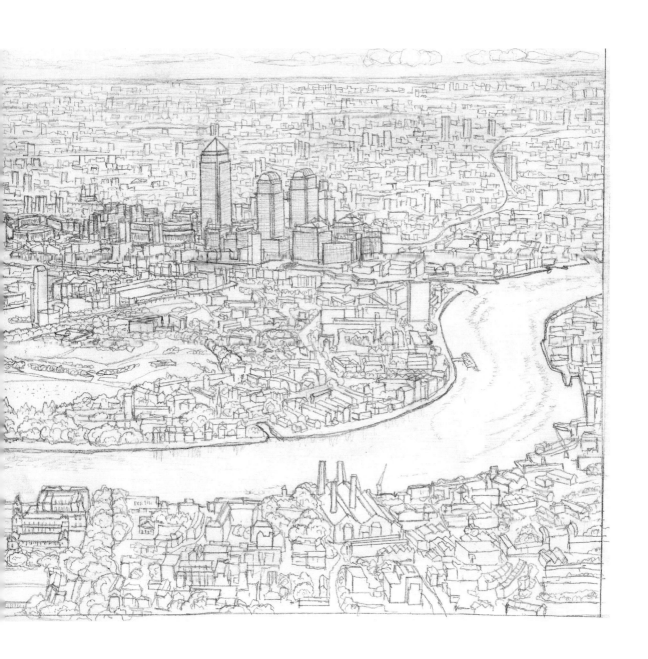

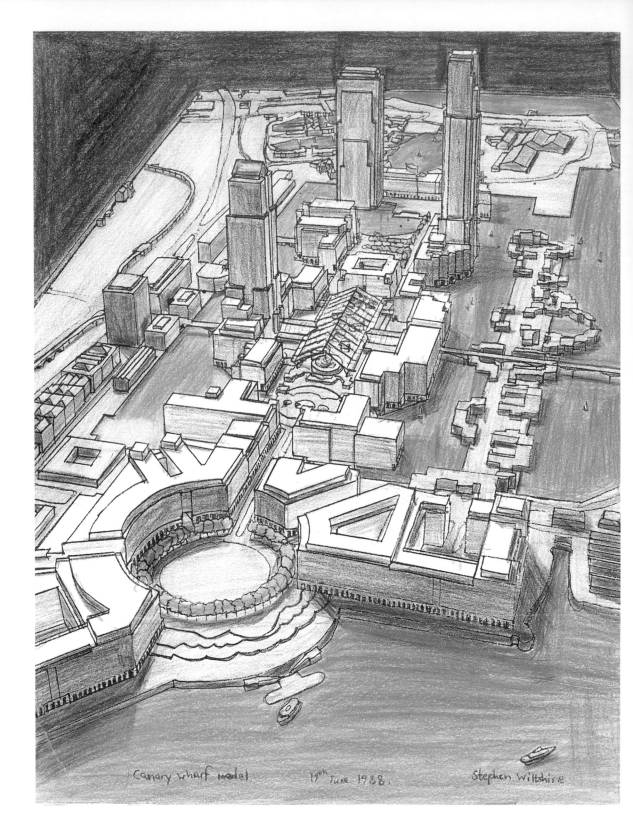

Canary Wharf Models

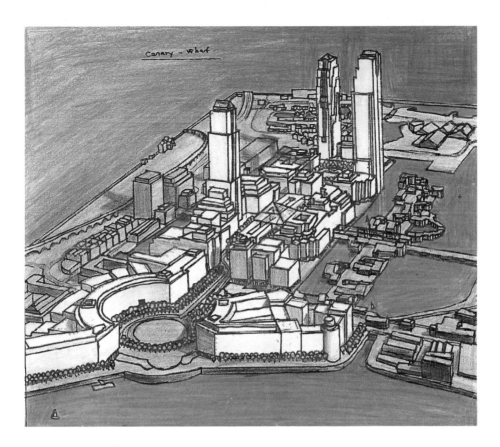

Canary - wharf.

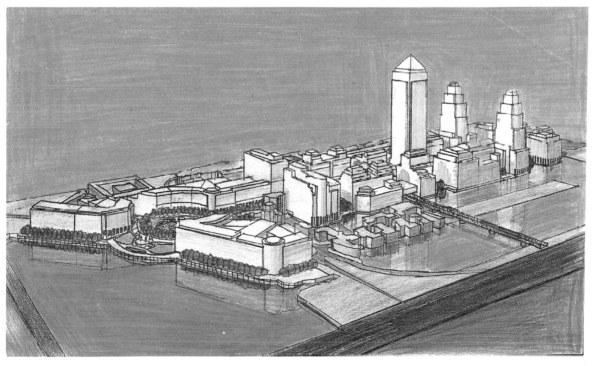

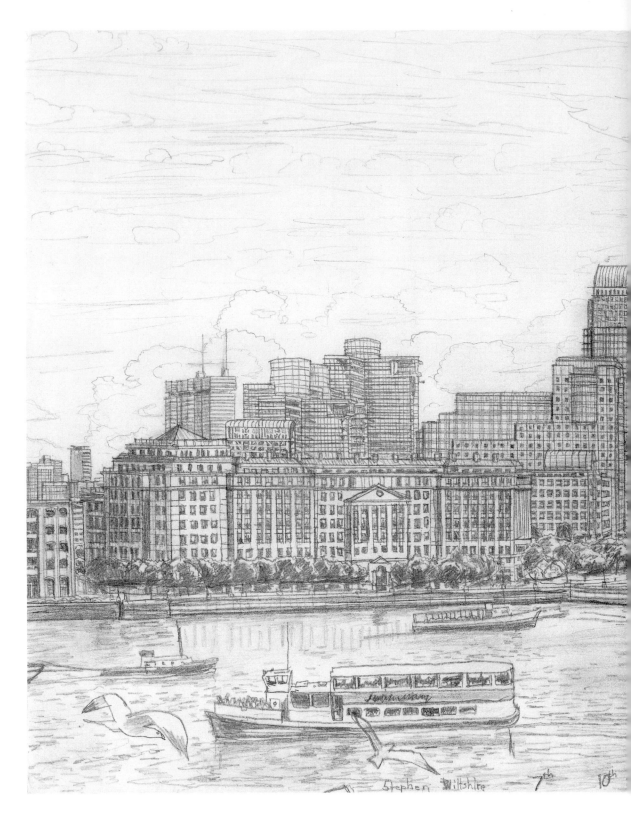

View of Canary Wharf from the water

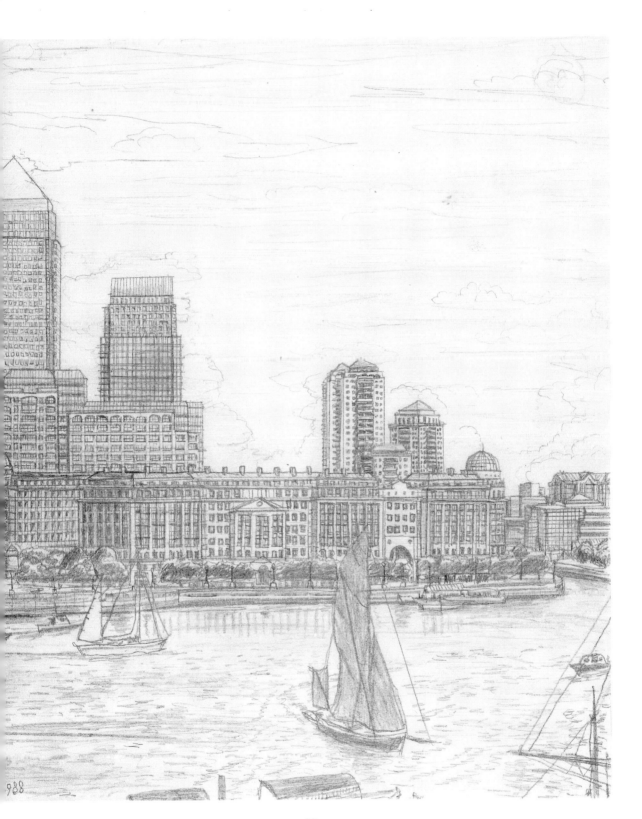

988

37

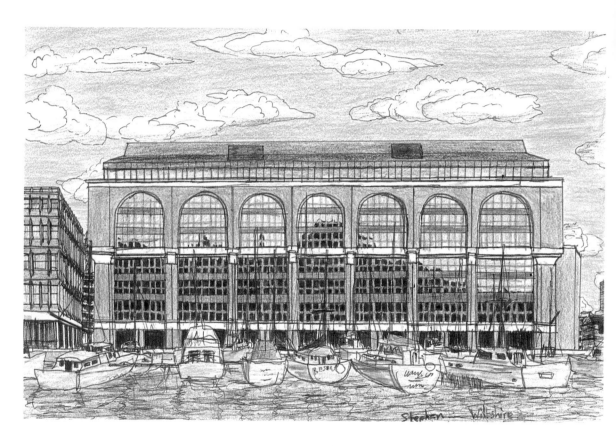

Commodity Quay, St Katharine's Dock

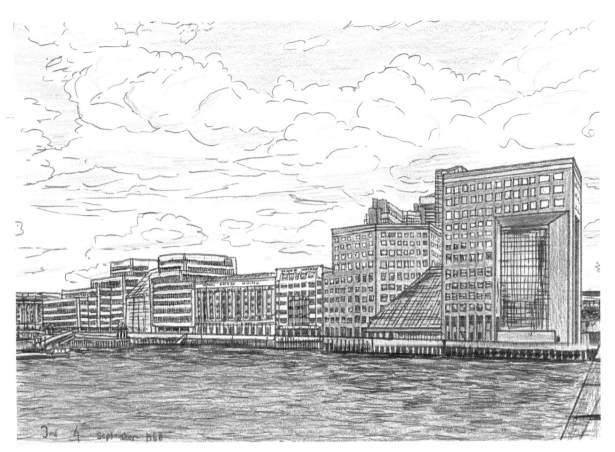

London Bridge City

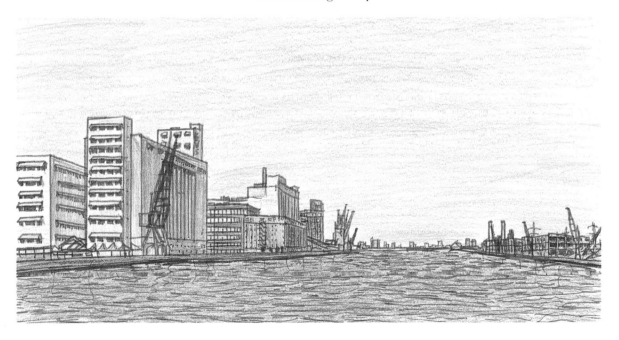

Royal Docks

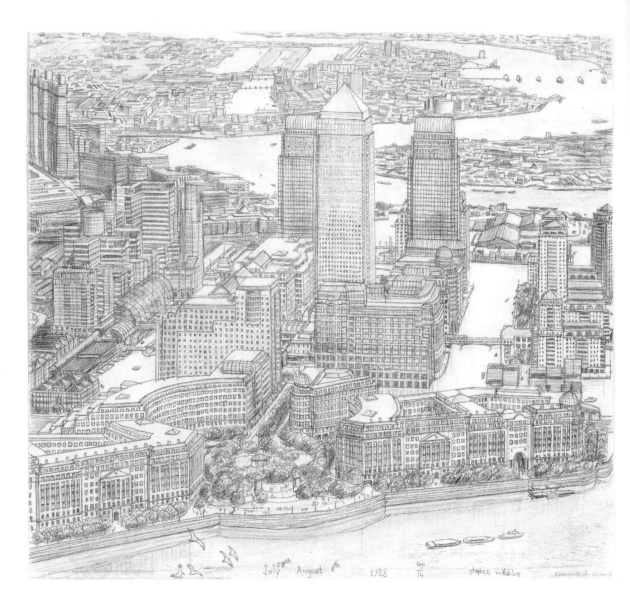

Canary Wharf

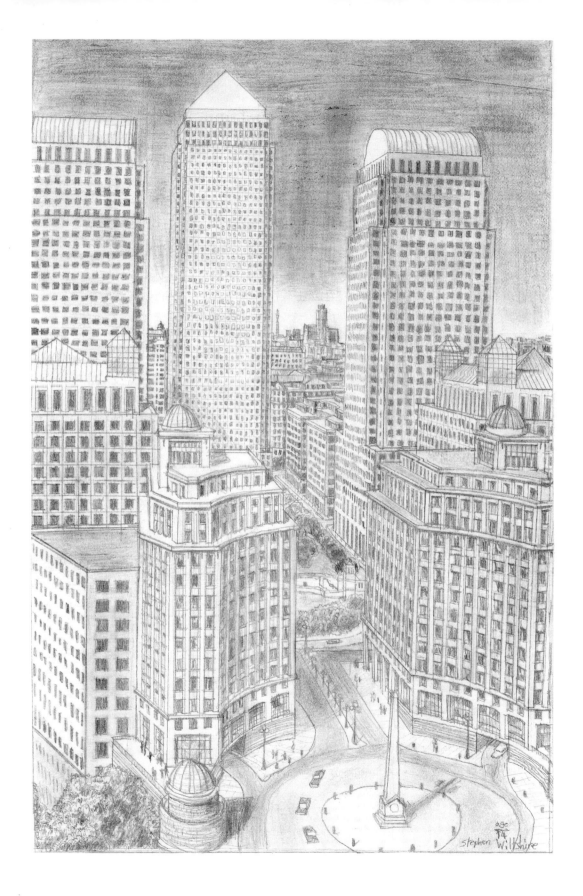

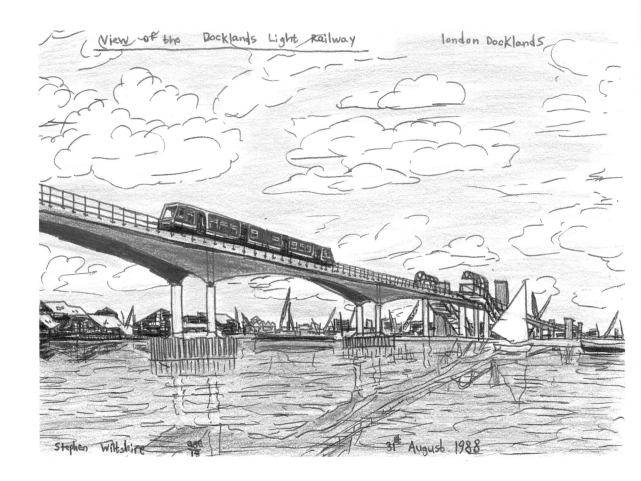

View of Docklands Light Railway

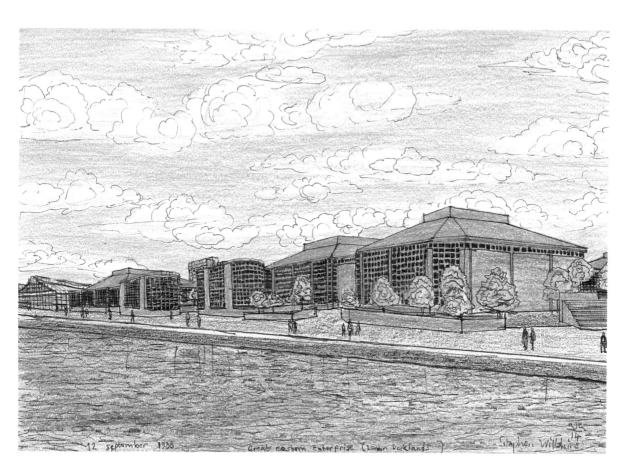

Great Eastern Enterprise

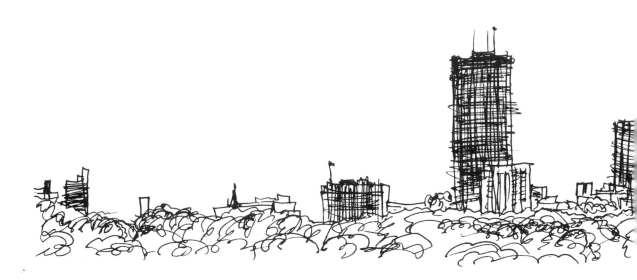

From Primrose Hill

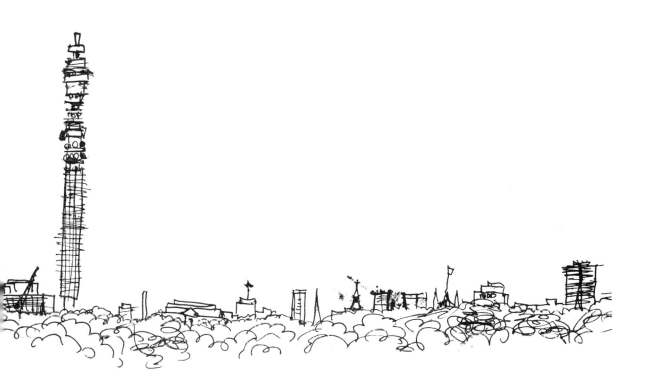

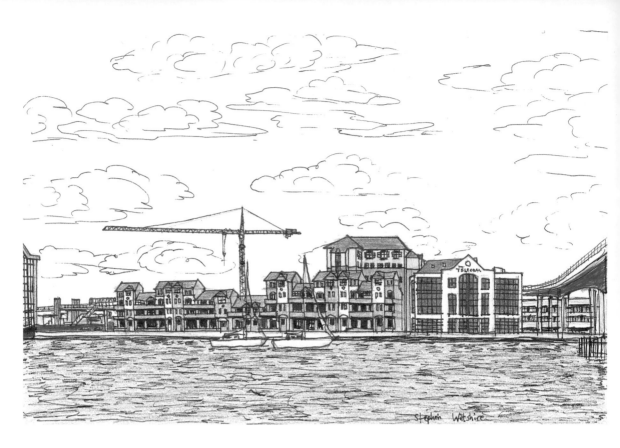

Waterside and British Telecom Building

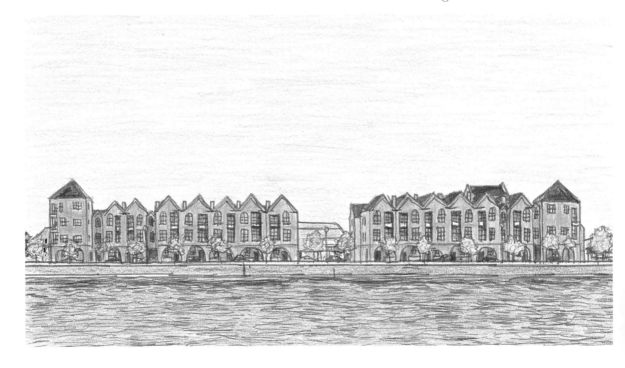

Brunswick Quay

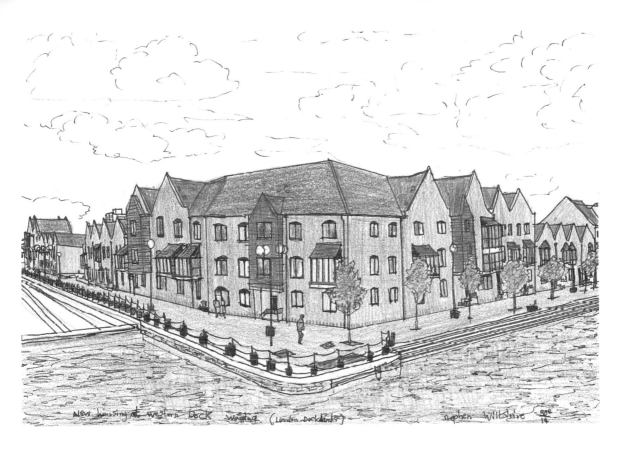

New housing at Western Dock, Wapping

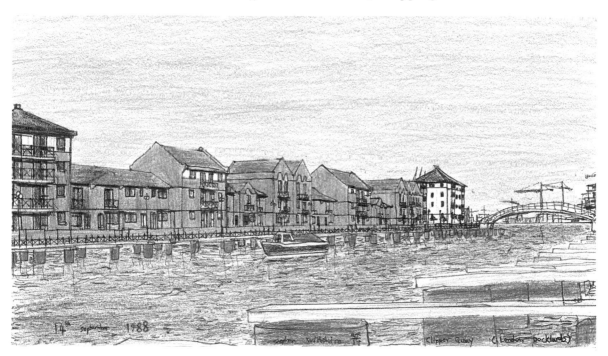

Clippers Quay

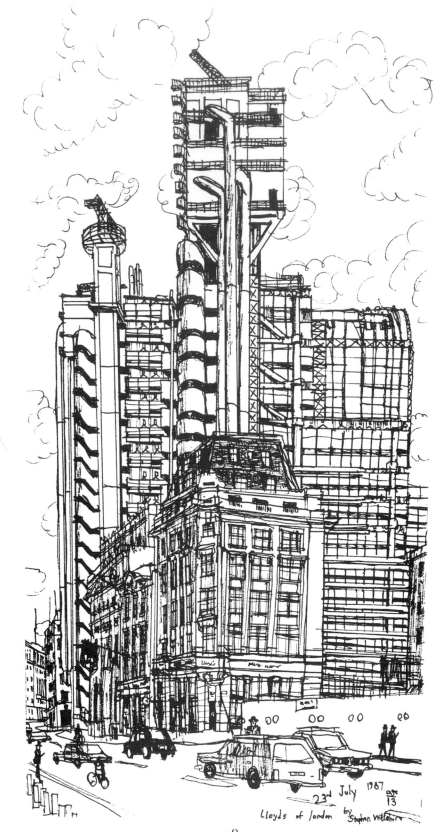

23ʳᵈ July 1987 age 13

Lloyds of London by Stephen Wiltshire

48

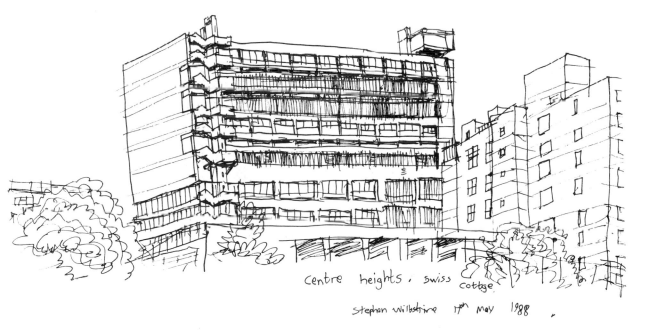

centre heights, swiss cottage

stephen wiltshire 17th May 1988

Centre Heights, Swiss Cottage

Lloyds Building

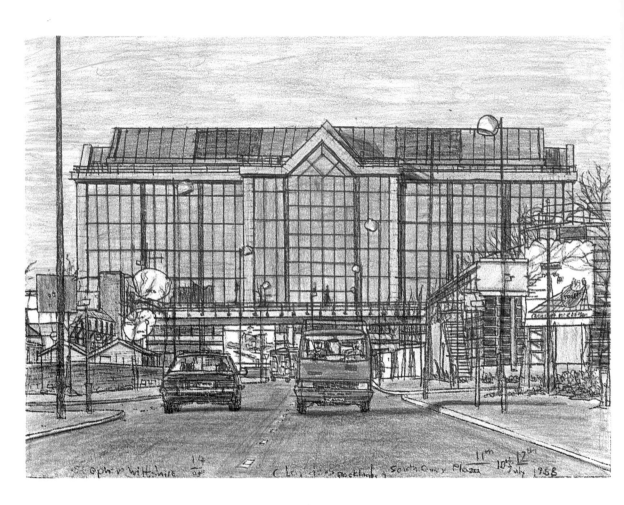

South Quay Plaza

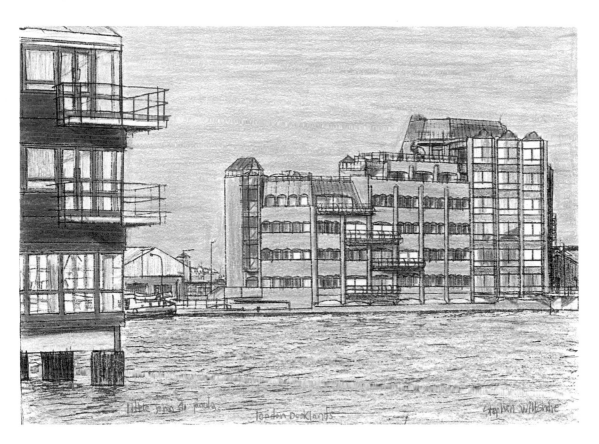

Littlejohn de Paula

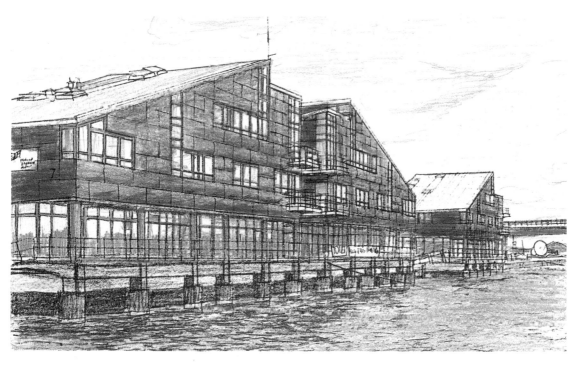

Heron Quays

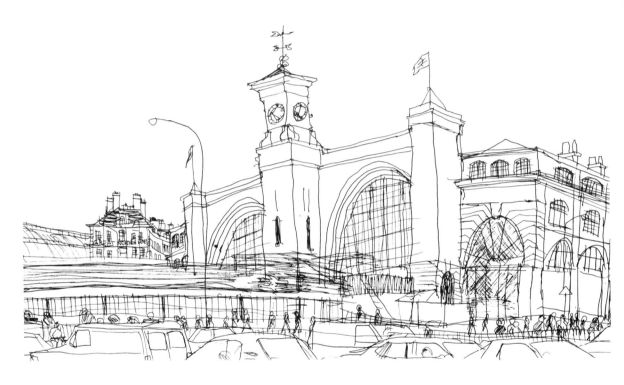

Views of King's Cross Station

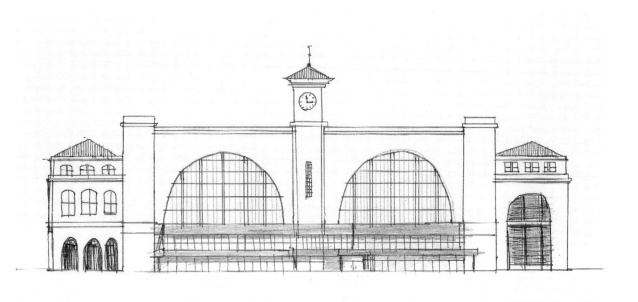

Stephen Wiltshire

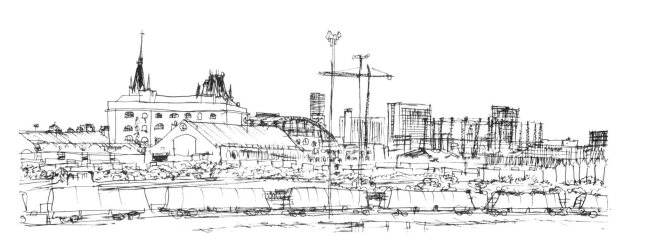

St. Mary Magalene church
in Paddington

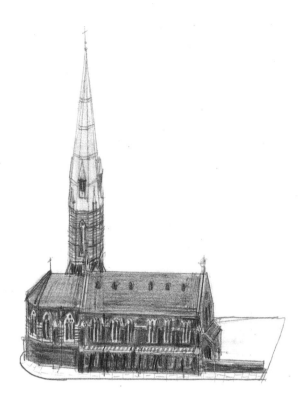

St Mary Magdalene Church, Paddington

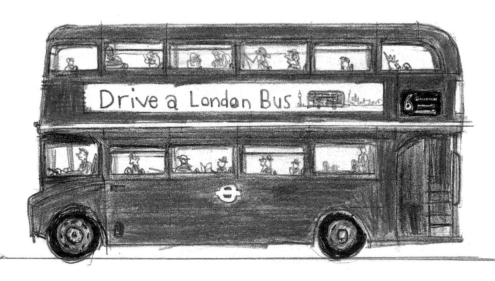

A London Bus

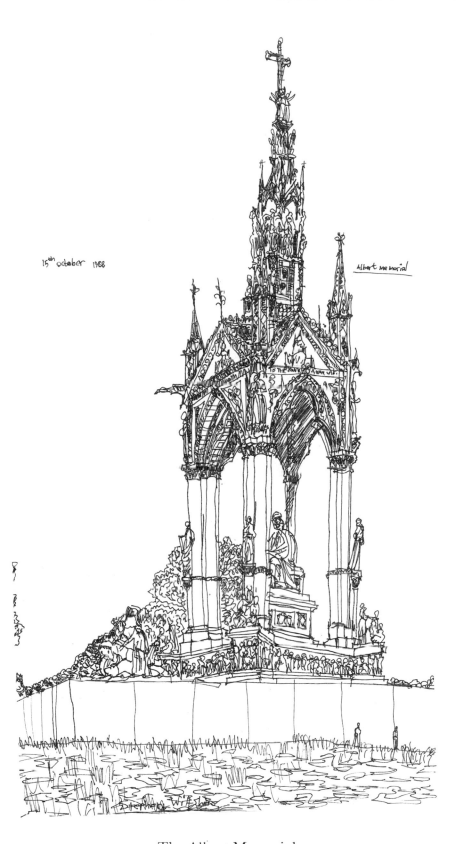

15th october 1988

Albert memorial

The Albert Memorial

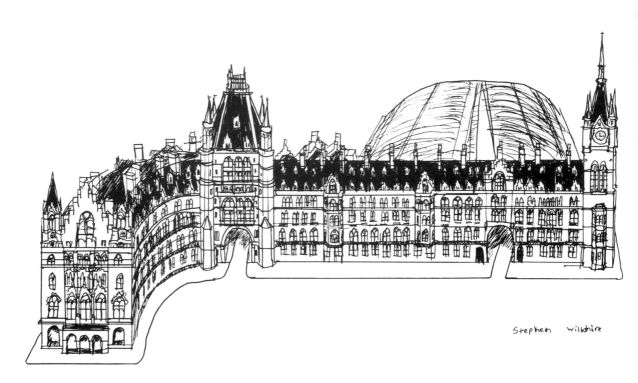

St Pancras Station

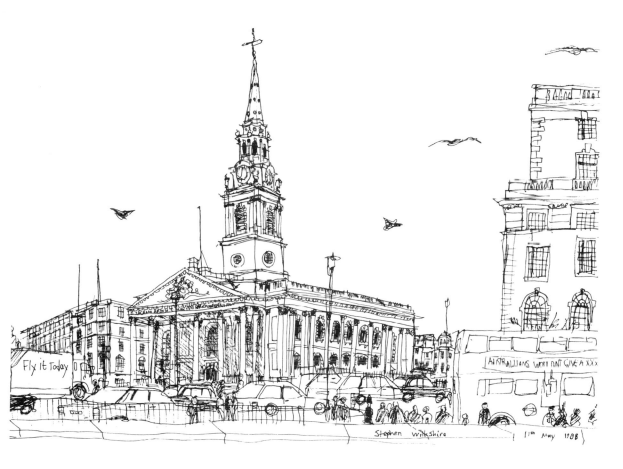

St Martin-in-the-Fields

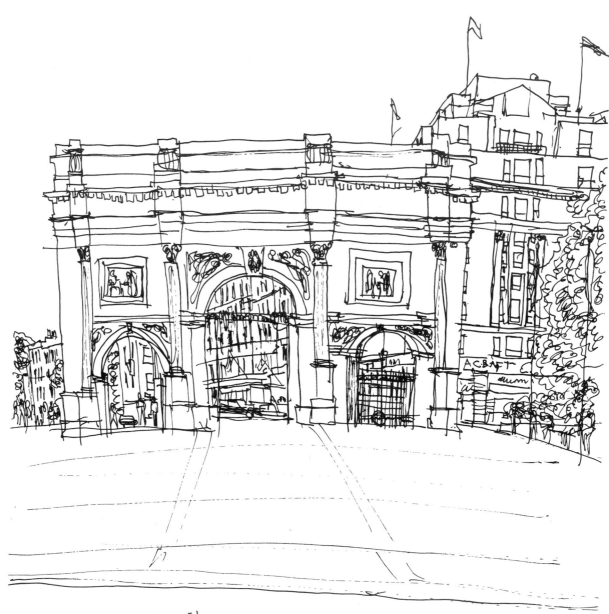

'Marble Arch.

Stephen Wiltshire 22nd June 1988

Marble Arch

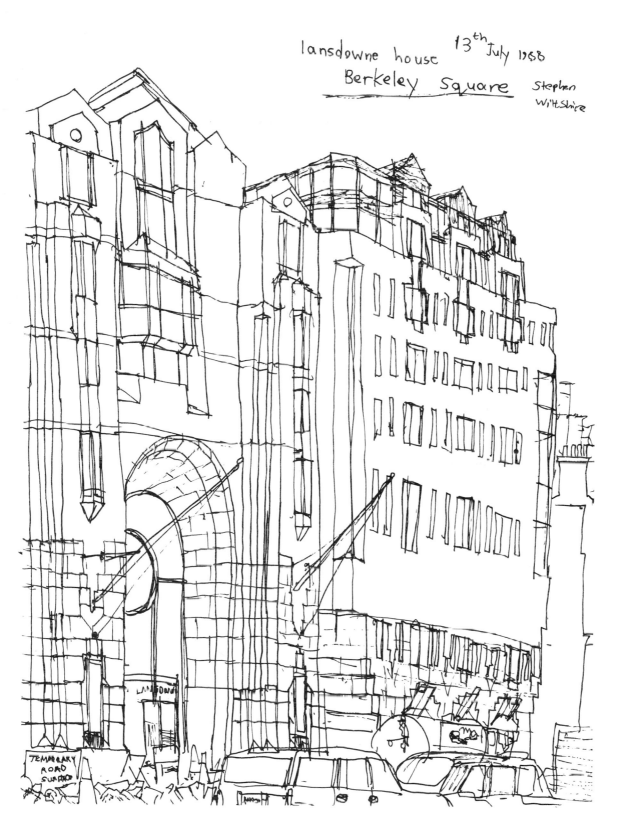

lansdowne house 13th July 1988
Berkeley Square Stephen Wiltshire

TEMPORARY ROAD SURFACE

Lansdowne House, Berkeley Square

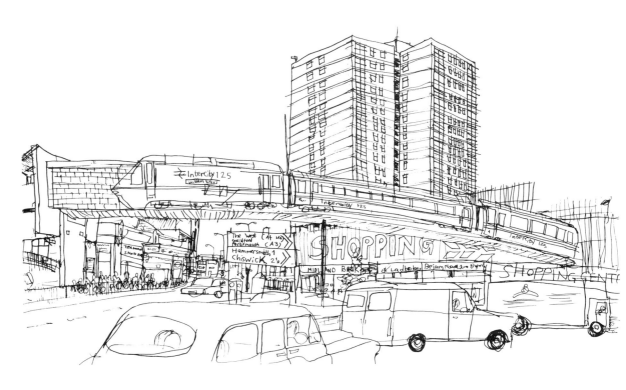

Shopping Centre, Shepherd's Bush

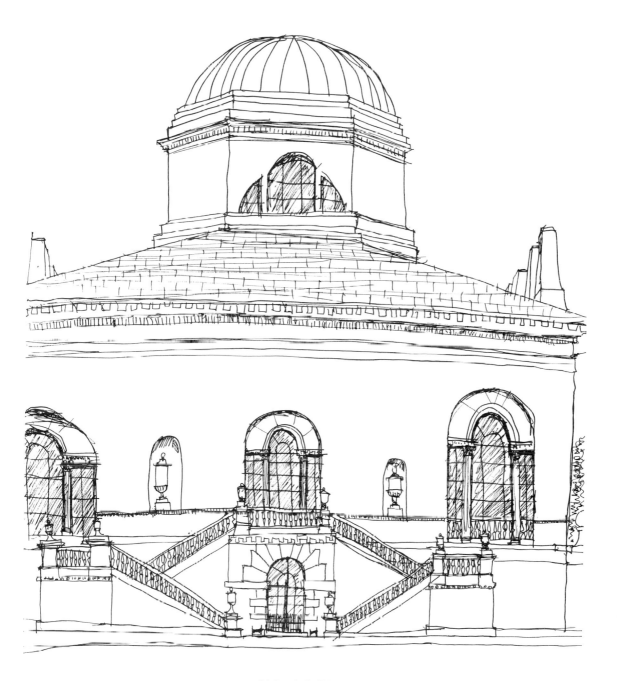

Chiswick House

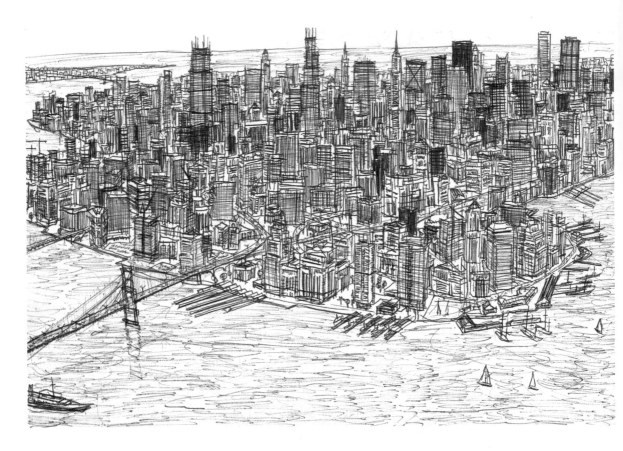

Imaginary City

SCOTLAND

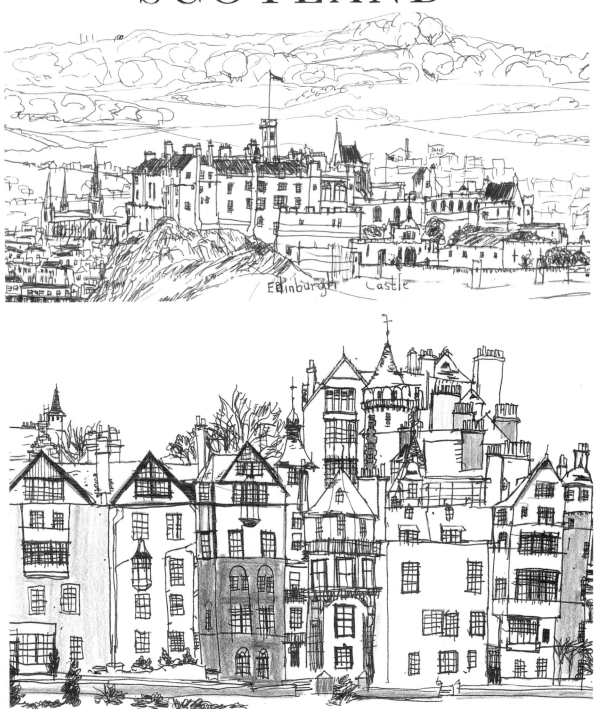

Edinburgh Castle

Ramsay Gardens

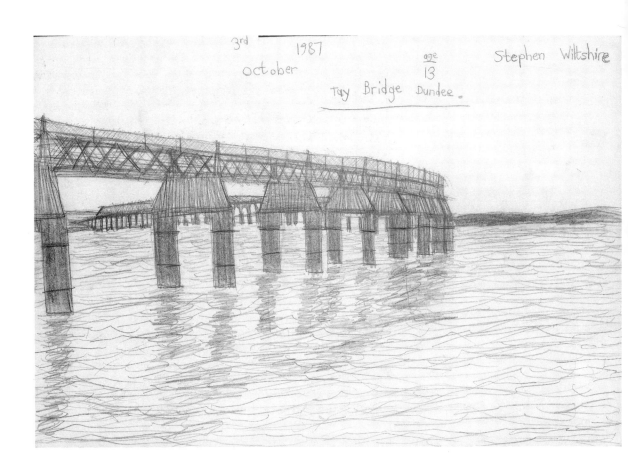

Tay Bridge, Dundee